COLORED READING:

COLORED READING:

The Graphic Art of Frances Butler

Little *Windows* *with* *Flags*

That *Wove* *In* *Them*

Lancaster—Miller Publishers Berkeley, California 1979

INTRODUCTION

*The flock of starlings rose from the trees,
circled twice and flew away.*

In semiotic jargon, graphic design implies a quick and simple connection between well-known metaphors (or clichés) in language and visual imagery. The effectiveness of the graphic depends on the viewer's recognition of the clichés and the particular realignment within the context of the illustration's purpose. Editorial art can make better use of metaphor than advertisements for products or events. But the graphic designer tries to shape the language to a focus that will illuminate a well-known idea, rather than to define new linguistic or visual frontiers.

Children learn to read both language and images. Adults should learn to read visual metaphors. While the complex language of William Burroughs is being absorbed and understood, visual imagery is still depicting men in space suits to suggest the limitless frontiers of science, or using the color red to sell beef soups. The spaceman in the *Nippon Moon Landing* fabric print is used as exhausted symbol.

In my graphic work I've tried to explore new possibilities for communication by isolating and emphasizing different parts of the visual repertoire to make the underlying theoretical emphasis become as important as the recognizable subject matter. I've used many different ways of rendering the subject including experiments with scale and proportion, and manipulation of decorative elements and color. But I always emphasize the interaction of language and image. Each presents only part of the total message and it is necessary to read both parts. This is contrary to the assumptions of most communication graphics in which redundancy is considered ideal, but is of no help in the search for new information which is essentially the process of connecting ideas not previously connected.

The effectiveness of visual imagery is not limited to the style or the techniques of depicting subjects. Just as important are the sizes of elements in relation to each other and to the page. A small image framed in the center of the page looks differently from a large image swelling out of the page. In some early posters, I tried to make all areas of the page equally important, not be enlarging one image, but by grouping small images into large shapes to lead the viewer through the sequential reading of all the little goodies that make up the whole story. I wanted to create an experience that was "just like at the movies," where one sees the entire screen constantly while refocusing on subtle gestures. The *Commencement* poster, the *Sandal Shop* poster and the *Try Calligraphy* poster, are typical of this movie-scenario style. In a further development of this style, *The Worried Man* and *The Beast in the Jungle* demonstrate an attempt to establish tension between the playful sparkle of small black and white decorative units and the more ominous overtones of larger black on white shapes. Tension establishes the mood of *The Worried Man*, while *The Beast in the Jungle* uses this theme

programmatically with the second fragmentary tiger not immediately recognizable. Delayed realization is the point of the Henry James story on which this work is based.

The abstract interaction of nonfigurative black and white shapes can lead to "mindless ornamentalism," which is demonstrated by the fabric prints, *Frog Pond* and *Cut Flowers*. This is also done with conscious effort and color in the *Hardware, Software* poster, but geometric jitterbugging (see *Ric & Rac*) has a limited vocabulary. Consequently, next I tried to use pictures of things that relate the character of the information quickly and simply.

In a series of film posters, I used simple outline images to present the subject of the film (the fierce old woman in *Day of Wrath*) or the critical elements (*La Strada*, including a section of roadway.) Occasionally metaphor was used—the floating skeletons in the poster for *La Guerre est Finie*, or the lost dog in the *Bicycle Thief* poster who reappears in the *Homemade Bed* print.

First I made prints, then printed books, often with text and toy-like images. *Wouldn't it be Wonderful to Welcome Loved Ones back from the Dead* incorporates reunited loved ones, Yama slicing through the veil of entanglements and the palm trees of paradise. The fabric print, *In the Yellow River*, juxtaposes trade products with a svelte Mao Tse Tung. My first two books, *Peachskin Preface* and *Bananaman in Switzerland*, were made from printed stuffed fabric that folded into pillow books (a physical pun on the erotic books of the female Japanese authors Murasaki and Sei Shonagon). They present a complaint about the stultifying impact of "Swiss style" graphic design—the corporate style of the sixties and seventies in posters and brochures.

Other fabric graphics include a series of tablecloth pieces ranging from the highly extended metaphor of a thirty-foot tablecloth (too large to show here) that engulfs the table and much of the floor for a chimpanzee tea party, to the autobiographical *Display*, which also covers much square footage and includes the quotation, "I used to be an artist but I just couldn't sit still that long."

In subsequent three-dimensional projects, I have pursued the interaction of space, form and image. *Space Printing* is a book that takes up twenty square feet, and the *Airwave* series establishes texts in a spatial sequence.

I have also explored the traditional book form which, more than any other communication medium, demands complete mental and physical participation from the reader. However, I felt the need for more detailed imagery.

In order to render facial expression and gestures more effectively, I began to make my images more precise, moving from the line drawing of the *Beyond Books* poster to a pointillism style much favored by medical illustrators and the religious magazines, *Awake* and *Watchtower*. An example of this style is the *Goodstuffs, Badstuffs* poster, a yearly announcement of the reject sale for my fabric company. In my first book from Poltroon Press, *Confracti Mundi Rudera*, I tried to fully elaborate the idea of parallel interacting texts, one visual, one verbal, in collaboration with my partner in the press, Alastair Johnston. Pictured gestures, glimpsed signs, and a chart inspired by a book from Japan, *Graphic Illustrations of Business under the Control of the Ministry of*

Communications (1915), carry out the theme, quoted from Horace, of fragments of a shattered world. In the plate "Continually Selecting the Wrong Tools," the drawing of a quiver is from another inspirational source, the *Koshu Jissu*, an early nineteenth-century Japanese catalogue of stone rubbings, Nōh masks, and armory. The idea of images moving around the edges of pages onto the following page is brilliantly presented in the *Koshu Jissu* (*Book of many Wonderful Things*). It was useful in my next book, *Logbook*, in collaboration with the English poet Tom Raworth. His text floats through a continuous environment of images, a maelstrom of shifting meaning in language and depiction, representing, as he put it, "all that remained after the great fire." He said in the *Logbook*:

> Subtlety is only what you see looking around inside your head with a torch: beating your radar pulse there to yourself and back and describing the journey. No, that was something else. Red. Until the day I ()ed that intelligence and intuition were the same, and passed through *that* fence. The word I choose so precisely becomes next day the key word in an advertising campaign to sell a brand of stockings, because the *word* means *what comes to mind first.* And as a "writer" and "artist" I should have sensed the direction of that word. As the Renaissance painter should have sensed his picture on the packet around those same stockings with SIZE NINE printed across the detail which took him three days to paint.

"We leap entirely to the quote," to quote Robert Creeley, and it is tempting when something is put so clearly and succinctly to quote it at length. (Curious readers are referred to *Logbook*, Tom Raworth, Poltroon Press, 1975.)

After the *Logbook* I adopted a laborious method of applying color called pochoir, a stencil process now quite obsolete. I'm publishing a portfolio with text by Alastair Johnston and myself of observed fashion, parallelling the smug pseudo-anthropological texts, and magnificently delineated native costumes of the fashion books published by Miller, Bulmer, and Racinet in the early 1800s. This book, *New Dryads (are ready for your call)* is an effort to view contemporary clothing and its wearers through the eyes of Democritos who said, "Images are bright spectacles in their clothing but heartless." The text is incorporated into the pictures as part of the composition, but the wearers are kept separate from the surrounding commentary—the way Bulmer's Ostiaks, wearing fish-skin coats, are kept from such judgmental remarks as, "when intoxicated, they become extravagantly gay; they sing and jump and make a noise, but on their return to their senses after taking some sleep, they seem to have forgotten everything that has passed."

Exploration of drawing gesture led me to photography, which is considered to be a "realistic" technique of presenting information despite the fact that even snapshots are realignments of the way we actually see things. Once again in my work, realism is diverted into metaphoric symbolism and diffused into colored collage. Some efforts have been made to use colors as precise symbols, but these are academic exercises. At the most, colors have general associative effect, although there are trends in the

colors used to show "reality" that can be precisely identified.

My colored photo-print collages are of images printed by letterpress, relief etchings or silkscreen over silverprint photographs. I make use of general color symbolism—light-value yellows, pinks, and blues for woven collages like the *Tigerbalm ascension* where the printed pink-suited rabbits fade into indefinite radiation. For the travel series I used light but indeterminate colors such as those in *Atlantean Crossing* and the promising "rainbow font" background of the *Typography* poster. However, for the *Rub for Riches* series, I used fuzzily rich, Persian carpet hues suggestive of Aladdin's frottage or the flannel prayer cloths hawked by religious mail-order houses.

Text has sometimes been submerged in an overload of photo images and color symbology in some of the latest color collages. However, primary to my work is the attempt to tell a continuous story through recognizable symbols and to reuse these well-known metaphors at an oblique angle as in the fabric print *Lisa Teasing the Mandrill*. The plate from the book *Colored Reading* of an old man staggering along carrying a wardrobe is at once a classical image (Pandora's box) and an open-ended invitation to speculate about the particulars of place, time, and color. It neatly demonstrates the interaction of social history and personal history which defines the term "colored reading."

Frances Butler
Berkeley, 1979

BIOGRAPHICAL NOTES

1. Born 1940, St. Louis, Missouri

2. Schooling in California, in history, at U.C. Berkeley and Stanford

3. Masters Degree in design (typography), U.C. Berkeley, 1964

4. Teaching: U.C. Berkeley 1966–1969, typography; U.C. Davis, 1970, book design

5. Goodstuffs Handprinted Fabrics: Emeryville, CA
 Established 1972, closed 1979

6. Poltroon Press, Berkeley, CA, press and publishing co.
 Established 1975, published books on poetry, typography and picture books

7. Selected group exhibits:
 Los Angeles County Museum of Art: "Block Brush and Stencil."
 November–December, 1972
 Victoria and Albert Museum, London: "Pop Fabrics," 1972
 Los Angeles County Museum of Art: "Anatomy in Fabric," February–March, 1973
 New York Art Directors Club: "Best Posters of 1972," August–September, 1973
 California Design 10, Pasadena, CA, 1974.
 Museum of Contemporary Crafts, New York City: "Clothing to be Seen," Spring, 1974
 Pasadena Art Museum: "California Design II," 1976
 Corcoran Gallery of Art, Washington, D.C.: "Images of an Era: the American Poster 1945–75," November 1975–January 1976.
 Smithsonian Institute: "The Object as Poet," 1977
 San Francisco Museum of Modern Art: "World Print Competition," 1977
 Cooper Hewitt National Museum of Design, New York: "The Artist's Postcard," September 1978
 Security Pacific National Bank, Los Angeles: "Space Printing," August, 1978
 The Grolier Club, New York: "Printer's Choice. Fine Press Printing, 1945–79," January–February, 1979
 San Francisco Museum of Modern Art: "Art for Wearing," September–October, 1979
 Visual Studies Workshop, Rochester, New York: "The Book as Object," November, 1979

8. Collections:
 Los Angeles County Museum of Art: Textiles
 Victoria and Albert Museum, London: Textiles
 New York Public Library: Books
 The Museum of Modern Art, New York: Books
 The British Museum, London: Books
 The Cooper Hewitt National Museum of Design, New York: Fabrics
 The Bank of America: Fabric Wall Hangings

1. *Commencement Poster.* 1971 diazo print, 24" x 40"; for the College of Environmental Design, University of California at Berkeley. A rapidly fading process for an evanescent occasion. "Listen, watermelons/if any thieves come/turn into frogs." (Issa)

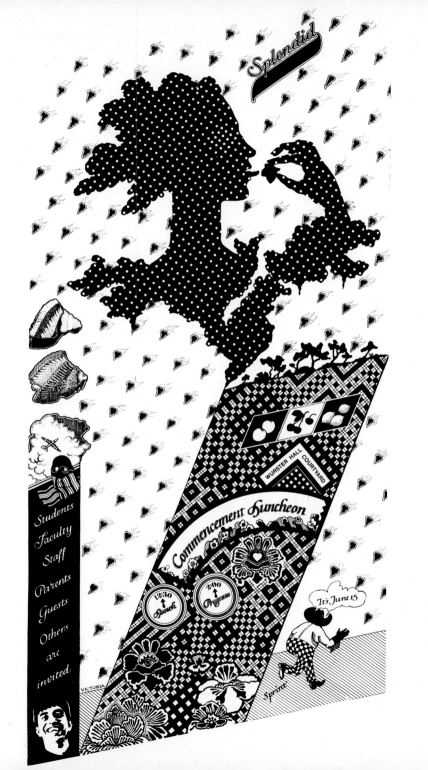

2. *Nippon Moon Landing.* 1973, fabric, 48" wide, printed at my fabric company, Goodstuffs Hand-printed Fabrics Company, Emeryville. "When I flew to Japan with a piece to give to Tadanori Yokoo in hommage, I discovered he was in Paris. Durer was even more surprised to be kimono-fabric in lunar setting. Pierre Bonnard's comment went unrecorded; Tadanori found out in the end."

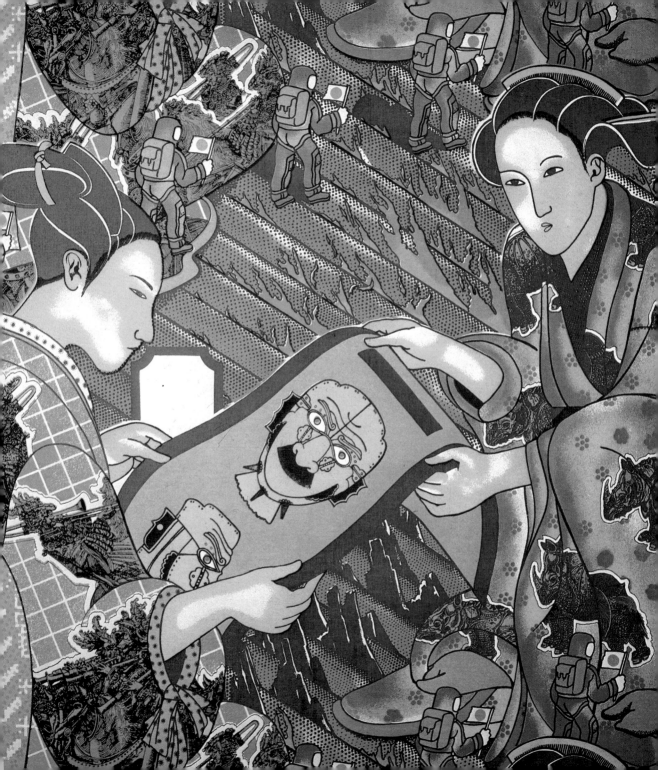

3. *The Sandal Shop.* 1972, offset-litho poster, wool for hand-wovens—shown here while still unprocessed—yet comes with the assurance of the donor of good work.

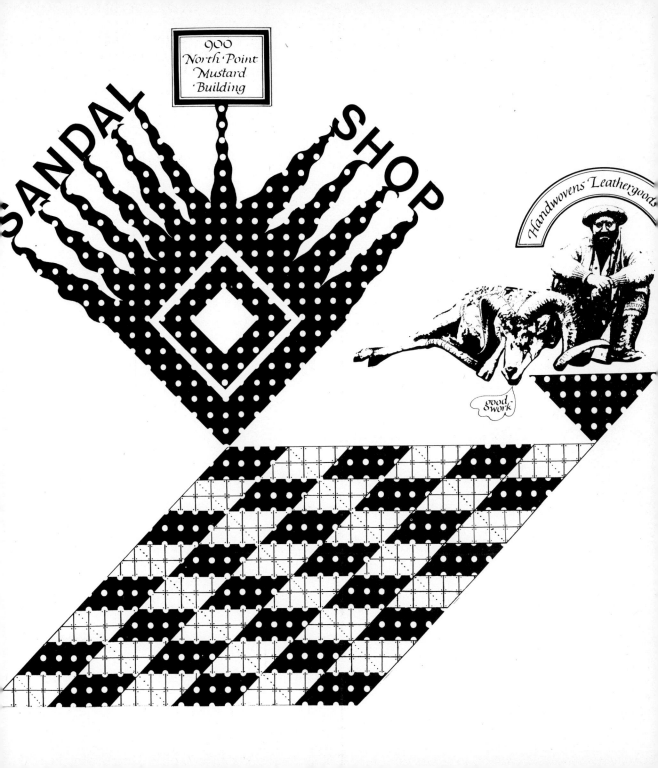

4. *Frog Pond.* 1973, fabric, 48'
wide, silkscreen on cotton b
Goodstuffs, Emeryville, California
An old pond (ya),/silence,
bodysnatched frog.''

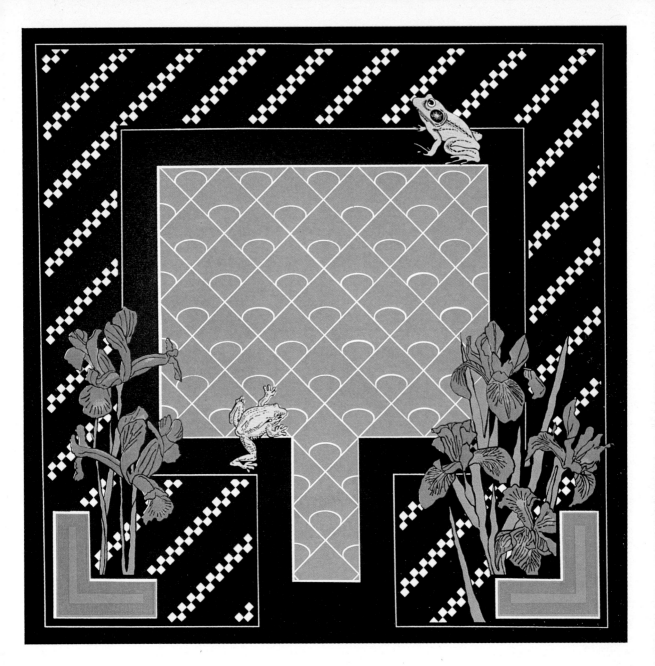

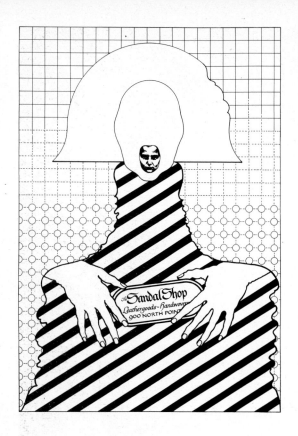 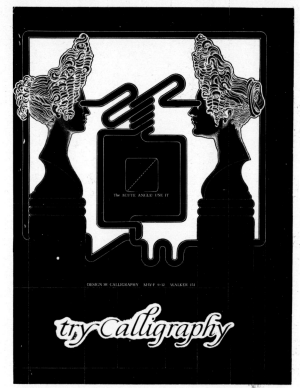

5. *Sandal Shop.* 1972, offset-litho poster, scale telescopes as apothegms dry up.

6. *The Acute Angle: Use It. Try Calligraphy.* 1971, diazo print, announcing my calligraphy class at U.C. Davis. Calligraphy employs all angles. Bibliography: *Images of an Era: The American Poster.* MIT Press.

7. *Cut Flowers.* 1976, fabric, 48'' wide, silkscreen on cotton by Goodstuffs, Inc. Flowers for the home-decorating market.

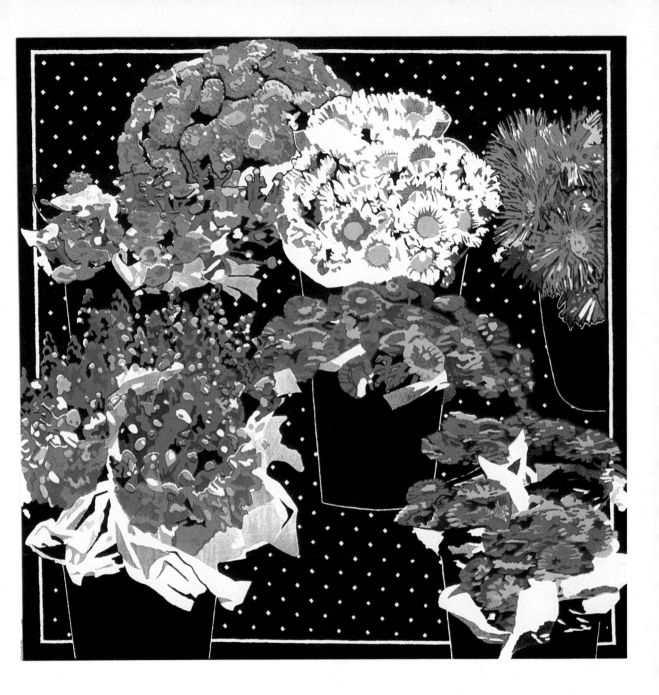

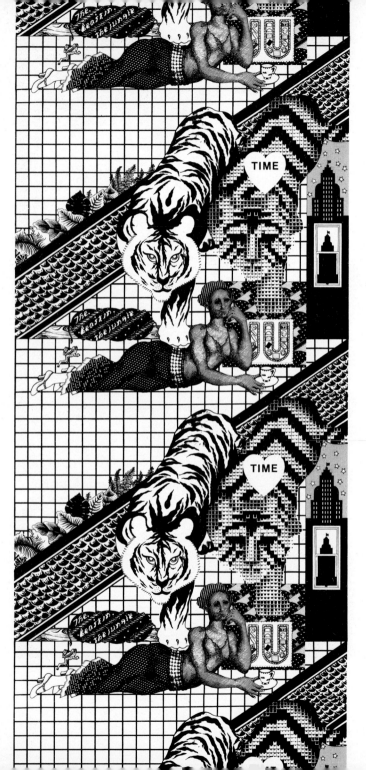

8. *Beast in the Jungle.* 1971, fabric 48'' wide, hand silkscreened on cotton by Goodstuffs. Tiger and delayed-reaction mate move in on a languid tea party.

9. *In the Yellow River.* 1972, 48'' wide, hand silkscreened on cotton fabric by Goodstuffs, Emeryville. An Oxford educated princess still winds up in a maze of packaging near the isle of Deshima and Mao Tse-tung in the current, moving continuously.

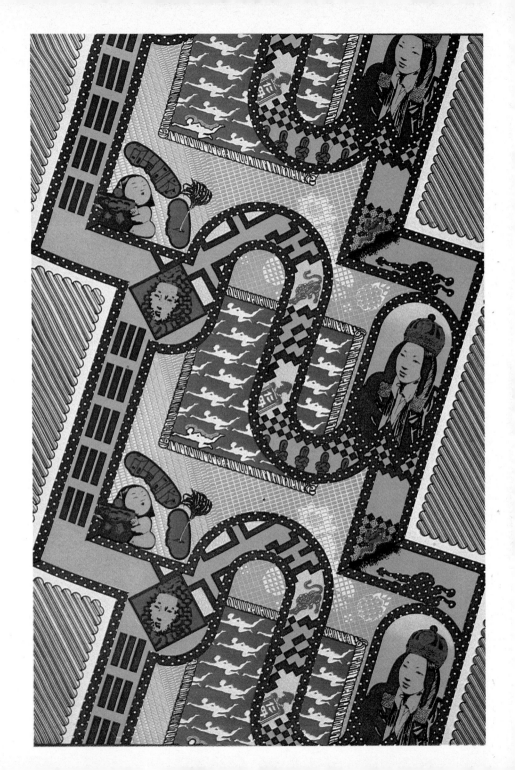

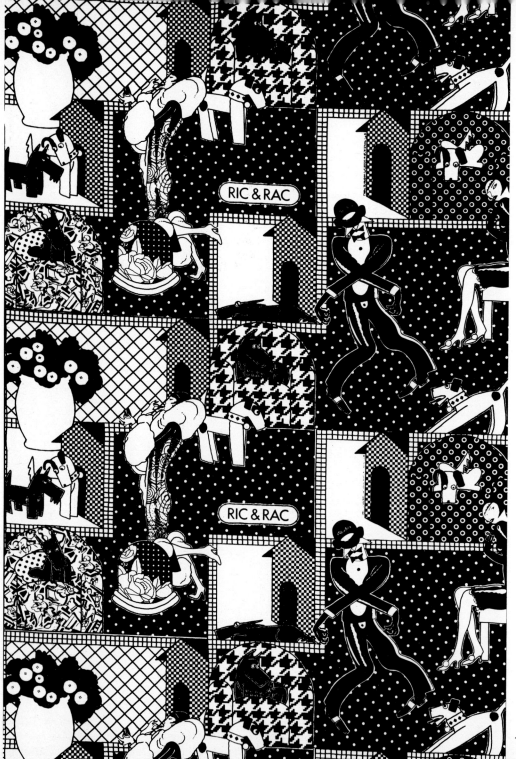

10.

10. *Ric and Rac.* 1973, fabric silk-screened on cotton for comforter. Loosely based on a risqué cartoon from the 'thirties by Pol Rab.

11. *Worried Man.* 1974, fabric, silk-screen on cotton, 48'' wide, printed by Goodstuffs Hand-printed Fabrics, Emeryville. Originally the front sheet of a two-layer calendar which could be segmentally torn off one month at a time, revealing the gradually changing character of the year beneath.

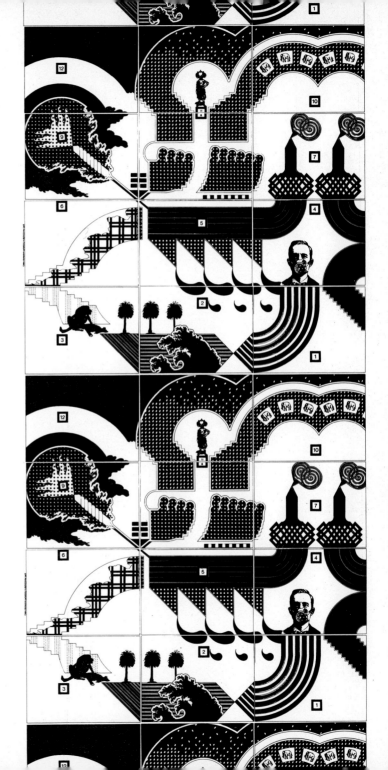

12. *l'Atlante.* 1972, 17'' x 22'' offset.
Posters for a University film society.

13. *The Descendant of Ghengis Khan.* 1972, 17'' x 22'', offset poster.

14. *La Strada.* 1972, 17'' x 22'', offset-litho.

15. *Bicycle Thief.* 1972, 17'' x 22'', offset-litho.

16. *La Guerre Est Finie.* 1972, 17'' x 22'', offset-litho.

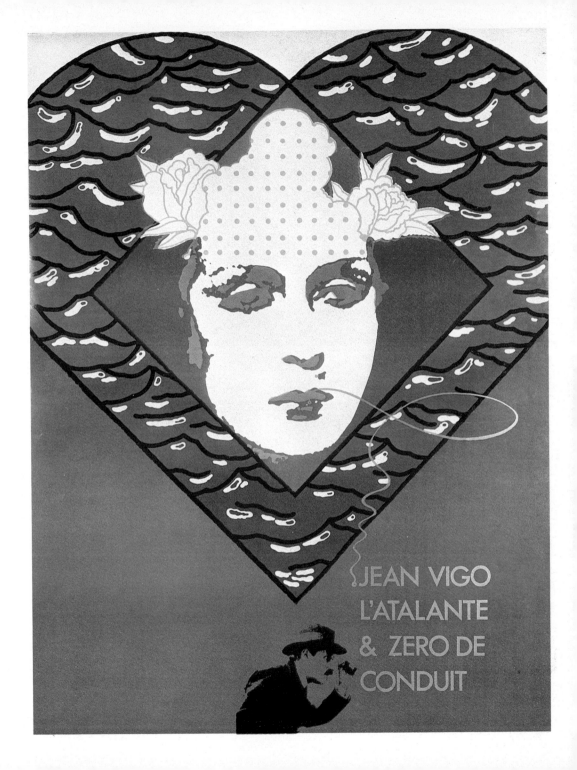

JEAN VIGO
L'ATALANTE
& ZERO DE
CONDUIT

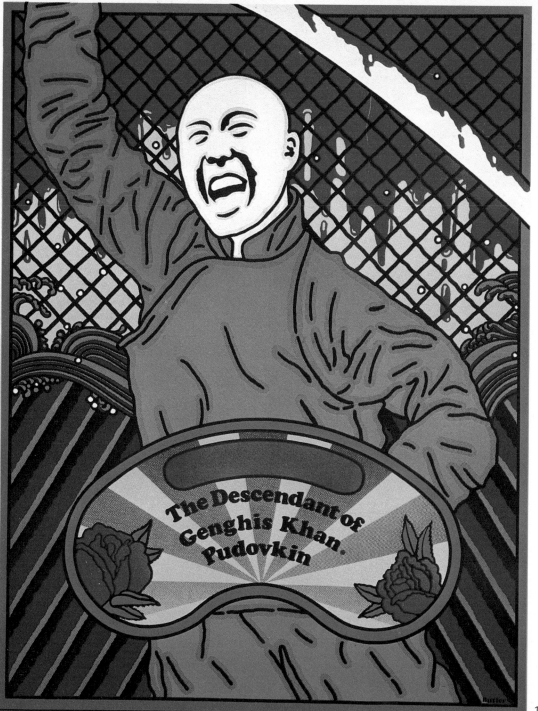

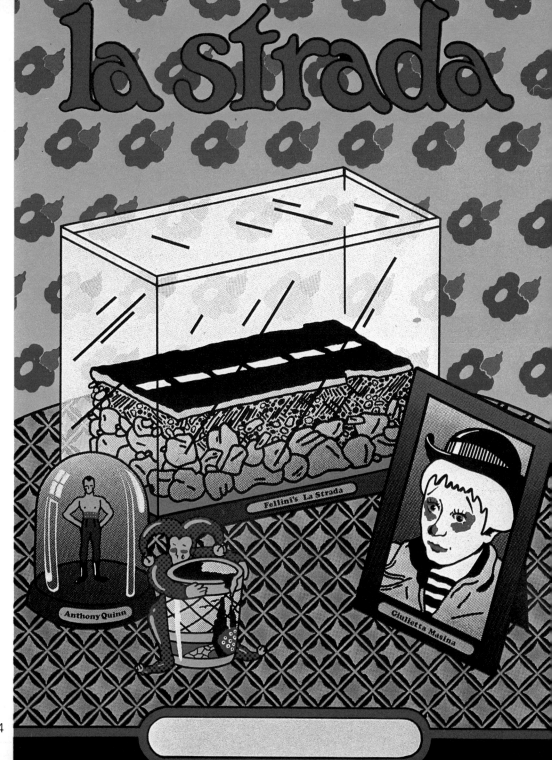

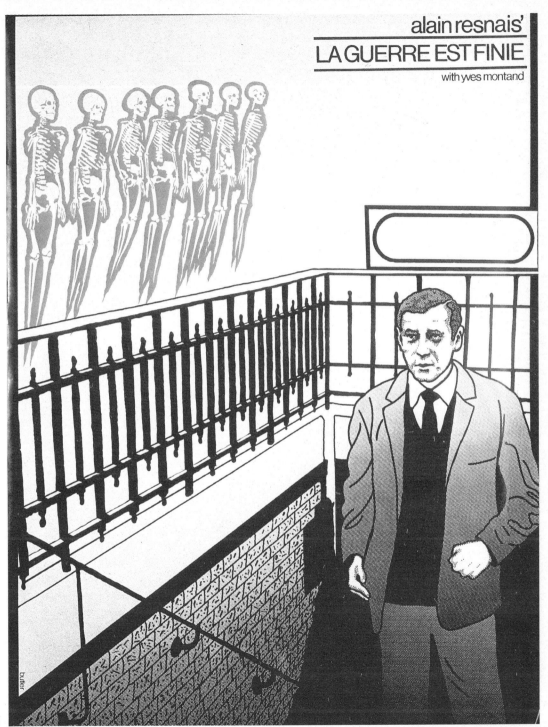

17. *Home Made Bed.* 1972, silk-screen on paper, 20″ x 24″ Olympic gymnastics.

18. *Hardware, Software.* 1972, silk-screen on paper. Reincorporated into the collapsed tea-table series as a heavily textured surface.

19. *Display.* 1974, part of a larger work involving stacks of folded printed tablecloths (here shown unfolded), scraps and fragments of paper. Revealing.

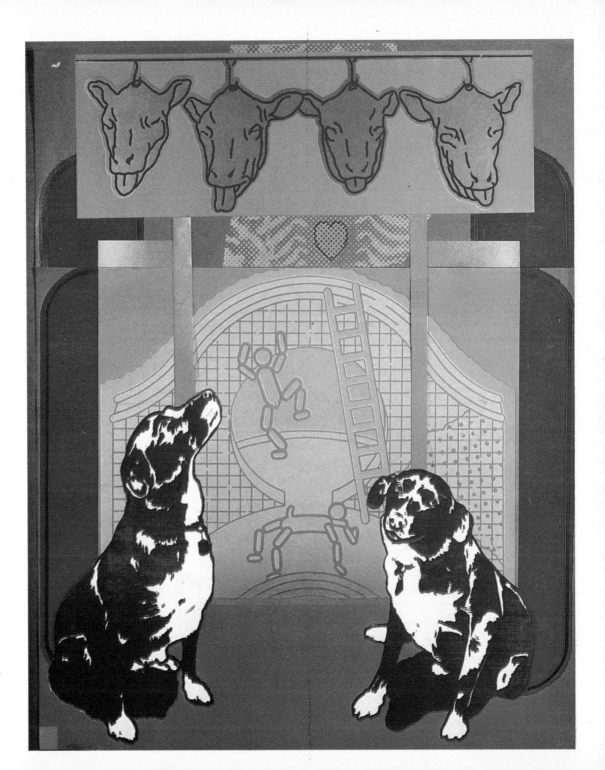

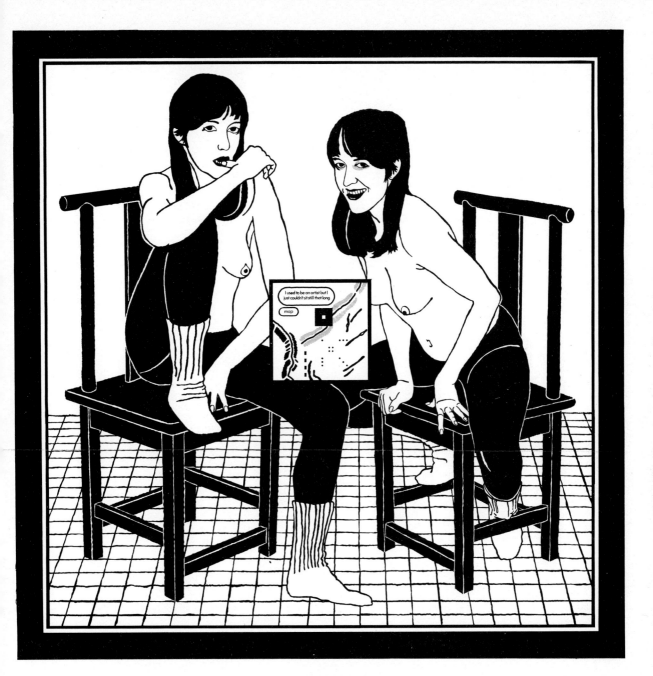

19

20. *Wouldn't It Be Wonderful to Welcome Loved Ones Back from the Dead.* 1973, 30'' x 40'', silkscreen on paper and clear plastic. A heartfelt emotion though it could lead to potentially embarrassing situations. Mixed media, and religious associations.

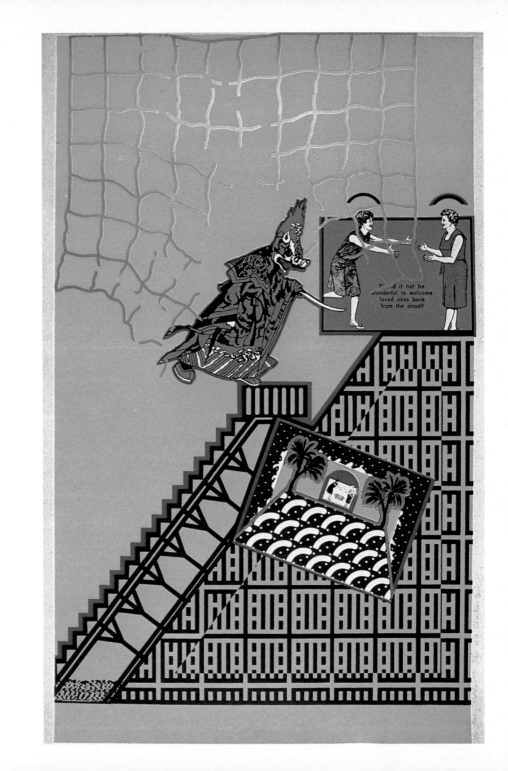

21. *Bananaman in Switzerland.* 197?
pillow book, silkscreen on cotton
In which a muscular "primitif"
converted to a sweet roll, typifyin
"Swiss Style" (Helvetica typ
used in an asymmetric grid sys
tem), as kitsch (sans options
Stylish swiss cheese then con
sumes all the dog biscuits.

22. *Beyond Books.* 1978, offse
lithography. A whispered mes-
sage to a sympathetic (Heart o
gold). Listening? 11" x 17".

23. *Lisa Teasing the Mandrill.* 1978,
fabric 45" x 45", silkscreened cot-
ton by Goodstuffs Handprinted
Fabrics.

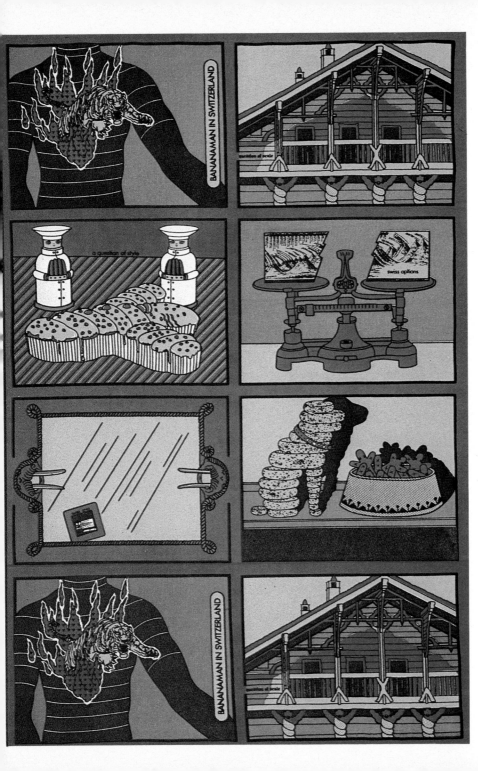

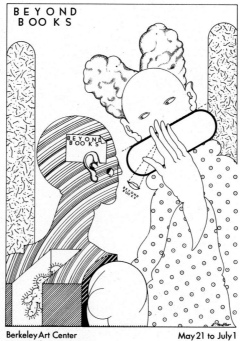

BEYOND
BOOKS

BEYOND
BOOKS

Berkeley Art Center May 21 to July 1
1275 Walnut Street 849-4120
Tuesday—Sunday 11-5
preview 7-10
ThursdayMay19
Books that transform the book—
extravagant, hand made, innovative.

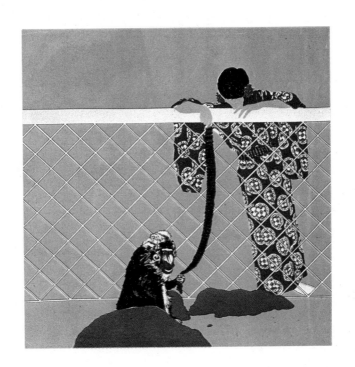

24. *Confracti Mundi Rudera.* 1975, letterpress book, sewn in the Japanese manner, Poltroon Press, 13" x 18" on a sengi echiren paper. Text by AMJ. Luminous-obscure bedtime reading for those who transcended 19th century sino-franco relations or the place of a kepi in a sharrawaggi landscape by Capability Brown. Bound in Zen Garden silkscreened cloth by Goodstuffs.

Incoherent ranting and () doxical raving.

25. *O.K. Dancers.* 1975, 18" x 24". The transcription of man's first walk in space also demonstrates military disobedience at the highest level. Cf. Post-orbital remorse. Pochoir colored.

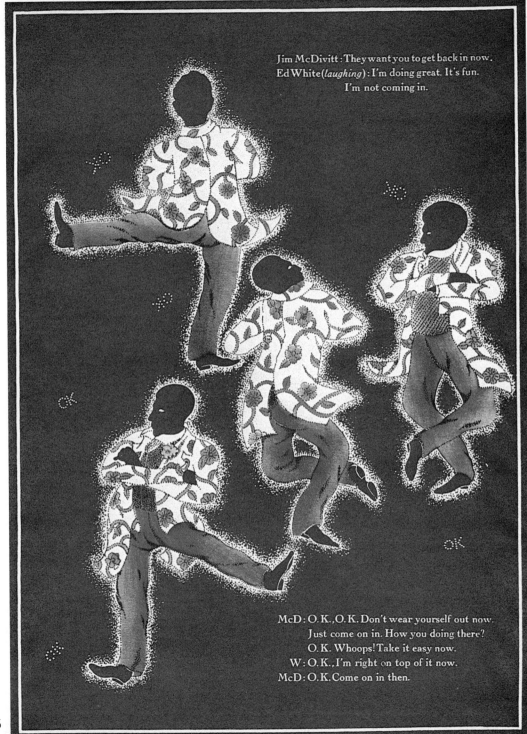

Jim McDivitt : They want you to get back in now.
Ed White (*laughing*) : I'm doing great. It's fun.
I'm not coming in.

McD : O. K., O. K. Don't wear yourself out now.
Just come on in. How you doing there?
O. K. Whoops! Take it easy now.
W : O. K., I'm right on top of it now.
McD : O. K. Come on in then.

25

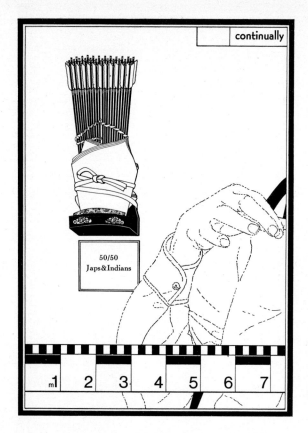

50/50
Japs & Indians

m1 2 3 4 5 6 7

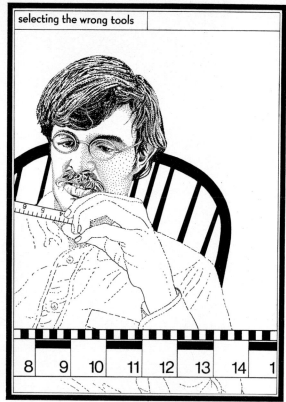

8 9 10 11 12 13 14 1

24a. Continually selecting the wrong tools. The measurement of fatal mistakes.

26. *Logbook*, by Tom Raworth, hand-set Bulmer type and magnesium relief etchings printed letterpress. 36 pages. The crumpled paper motif reveals more as the story progresses; incorporates collage and pochoir over a basically conservative book format. Printed on dampened Arches coverstock and bound in boards covered with silkscreened cloth "Rock" fabric. Handprinted by Goodstuffs of Emeryville, 1976.

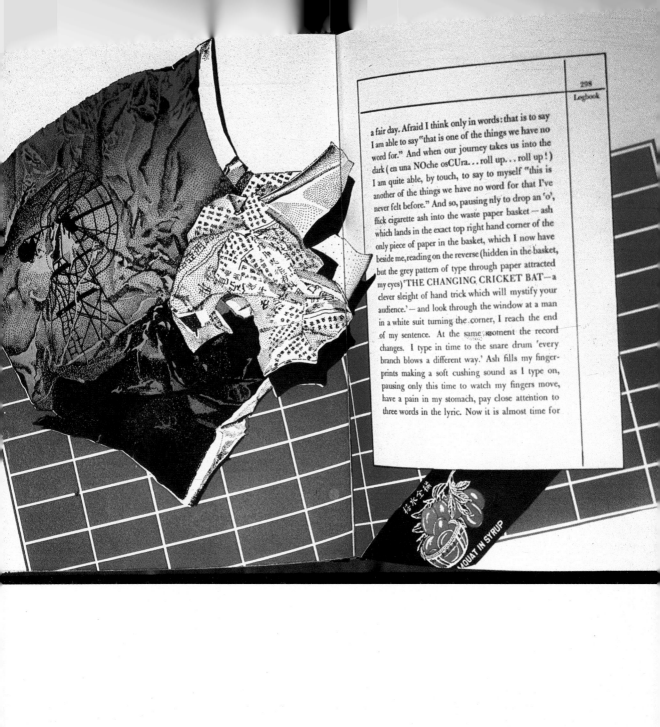

a fair day. Afraid I think only in words: that is to say I am able to say "that is one of the things we have no word for." And when our journey takes us into the dark (en una NOche osCUra . . . roll up . . . roll up !) I am quite able, by touch, to say to myself "this is another of the things we have no word for that I've never felt before." And so, pausing nly to drop an 'o', flick cigarette ash into the waste paper basket — ash which lands in the exact top right hand corner of the only piece of paper in the basket, which I now have beside me, reading on the reverse (hidden in the basket, but the grey pattern of type through paper attracted my eyes) 'THE CHANGING CRICKET BAT — a clever sleight of hand trick which will mystify your audience.' — and look through the window at a man in a white suit turning the corner, I reach the end of my sentence. At the same moment the record changes. I type in time to the snare drum 'every branch blows a different way.' Ash fills my finger-prints making a soft cushing sound as I type on, pausing only this time to watch my fingers move, have a pain in my stomach, pay close attention to three words in the lyric. Now it is almost time for

27. *New Dryads* (are Ready for your Call), 1979, with text by AMJ and FCB. Handset Bulmer type and relief printed magnesium plates, letterpress and pochoir, 25 plates, 20'' x 24''; edition of 15. This laborious and obsolete process is slower than handcoloring because each print requires fifty to seventy stencils, but this method assures a uniform edition.

NEW DRYADS

BEING a suite of *pochoir*-colored prints

Conceived and Executed by the Artist : :

F R A N C E S B U T L E R

depicting Fashionable Dress observed in

the Diurnal Realm : the Letter-press by

the publishers : *Poltroon Press*, Berkeley.

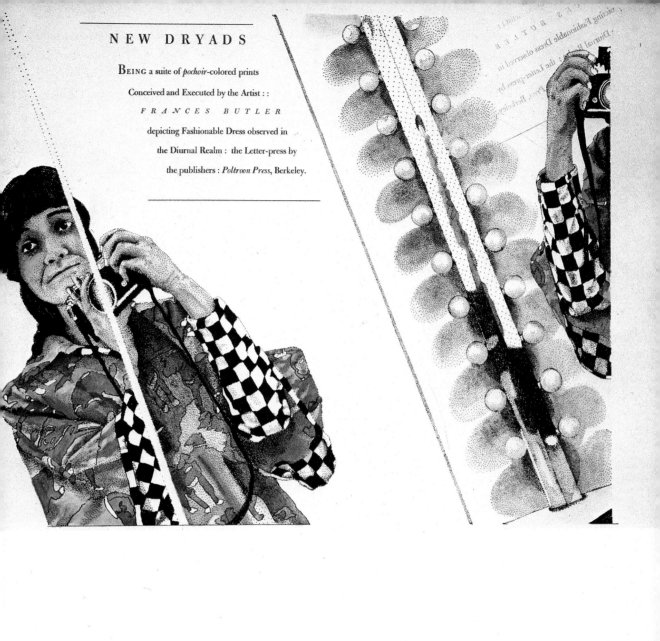

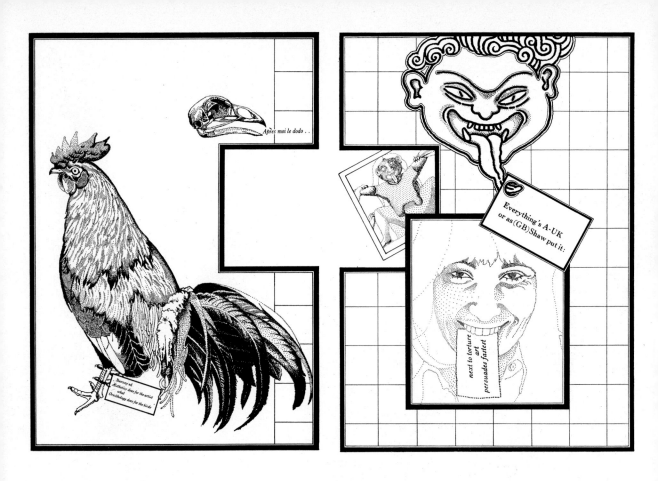

24b *Après moi le dodo.* As Barney said, ''aesthetics does for the artist what ornithology does for the birds.''

28. Amsterdam

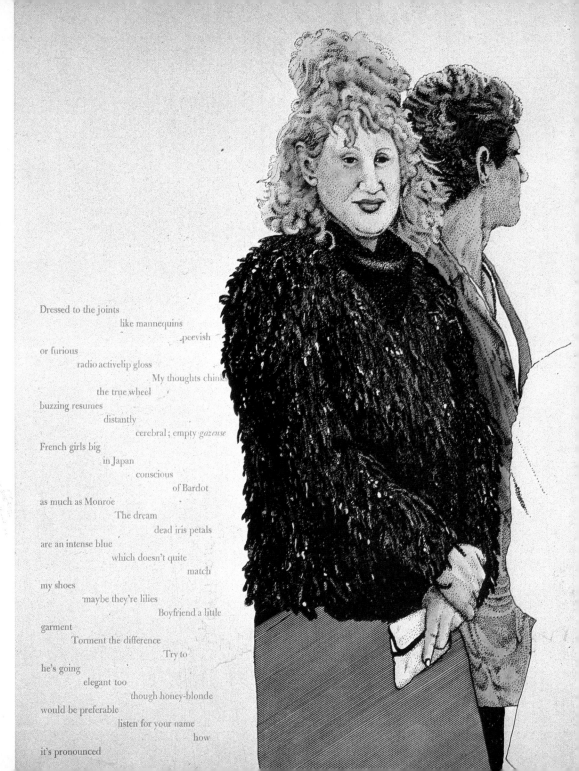

Dressed to the joints
 like mannequins
 peevish
or furious
 radio activelip gloss
 My thoughts chinks
 the true wheel
buzzing resumes
 distantly
 cerebral ; empty *gazeuse*
French girls big
 in Japan
 conscious
 of Bardot
as much as Monroe
 The dream
 dead iris petals
are an intense blue
 which doesn't quite
 match
my shoes
 maybe they're lilies
 Boyfriend a little
garment
 Torment the difference
 Try to
he's going
 elegant too
 though honey-blonde
would be preferable
 listen for your name
 how
it's pronounced

29. *Goodstuffs Baadstuffs.* Re-knowned ice cream man vending dubious wares. Handset Cochin type and relief etching (magnesium)-printed letterpress. 18″ x 24″, 1975.

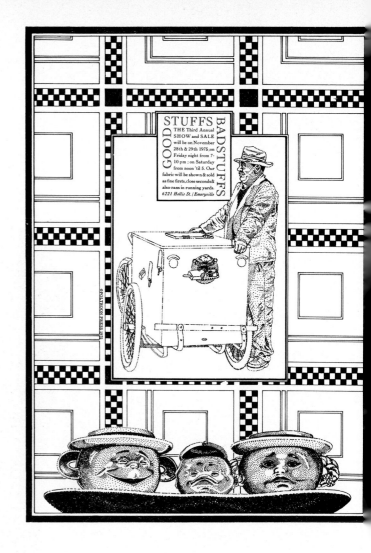

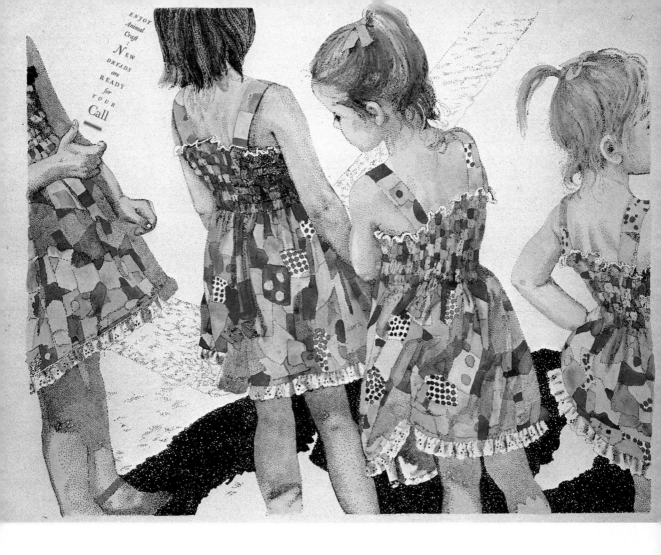

30. The New Dryads

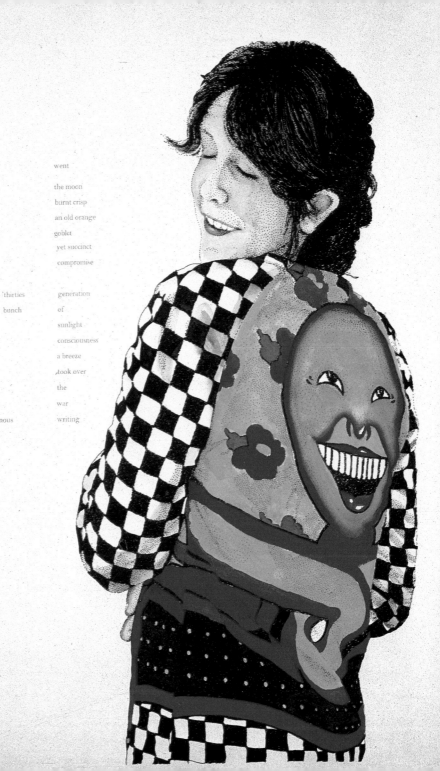

Helen went

through the moon
sunlight burnt crisp
established an old orange
 goblet
of joy yet succinct
green shell compromise
from home
way back to 'thirties generation
winning a bunch of
metaphysical sunlight
perfect consciousness
of life a breeze
a thirst took over
during the
trojan war
writing indigenous writing

32. *Tigerbalm Ascension.* 1979, 4-color letter press and woven silkscreen paper and collage. Rabbits carrying peaches to a pig like god. A movie that won't b remade; the Tiger Balm Garden in Hong Kong are slated for demo lition.

33. *Atlantean Crossing.* 1979, 20" 24", letterpress and mixed medi collage, specially printed waste paper parts are incorporated into series of "found" images.

34. *Rub-Don't-Blot* from the Rub fo Riches series. Photographic sil verprint and mixed-media collage incorporating airbrushed paper letterpress strips and polaroi photos of trays of money with the money cut out—inspired by a mai order "prayer rag" which prom ised riches as a result of using the rag.

35. *Color Theory.* 1979, 18" x 24" Advertisement for a class. Printed letterpress on paper and fabric.

36. *Typography and Letterpress Printing at U.C. Davis.* 1979. A poster printed letterpress with a rainbow font scheme that varies from print to print involving several closely misregistered (intentionally) over-printings. 18" x 24".

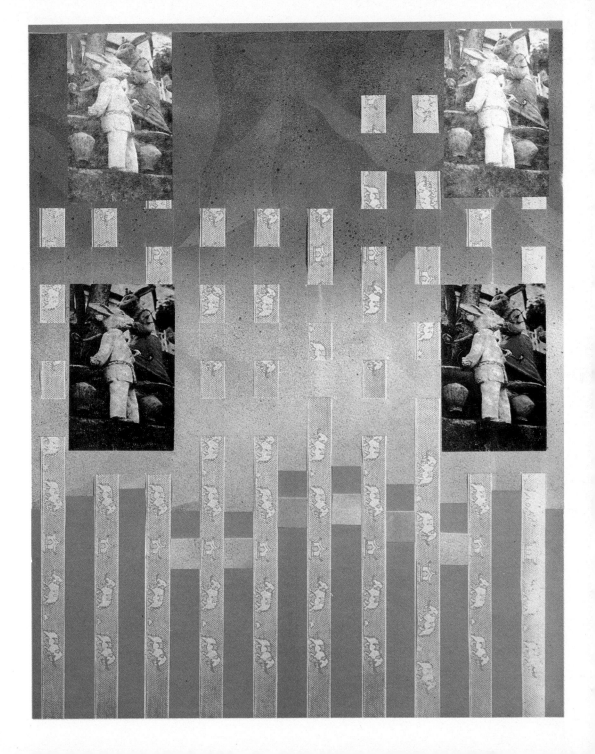

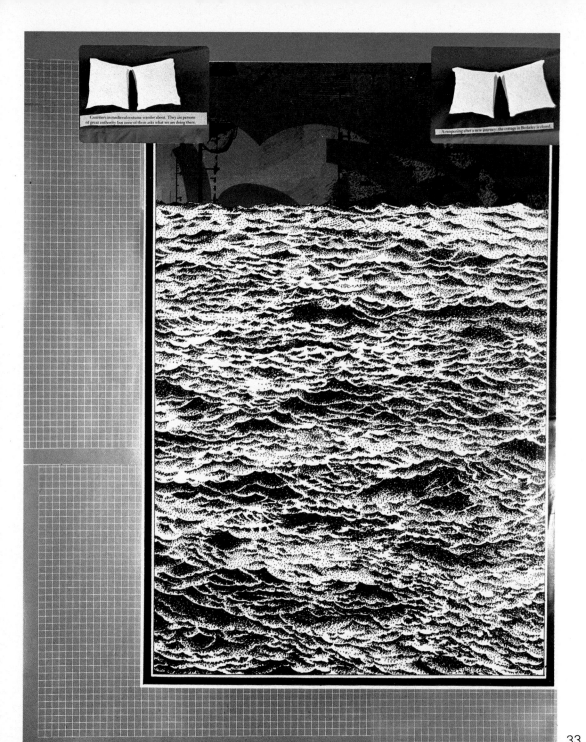

Courtiers in medieval costume wander about. They are persons of great authority but none of them asks what we are doing there.

A reopening after a new journey; the cottage in Berkeley is closed.

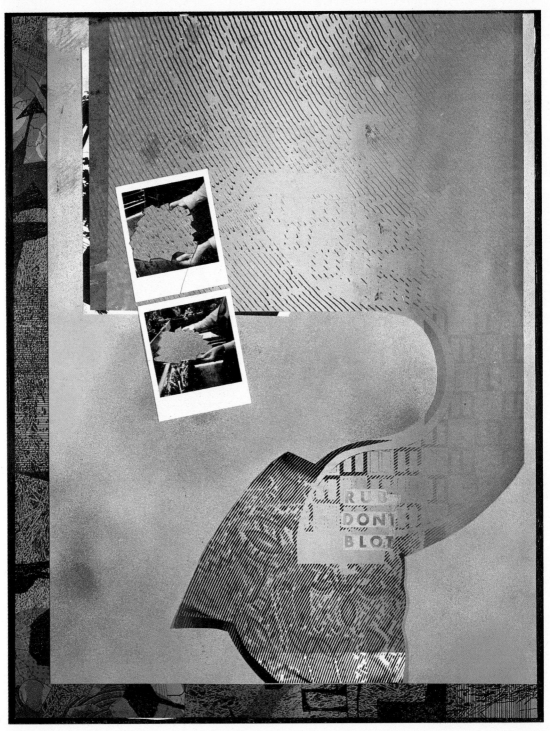

34

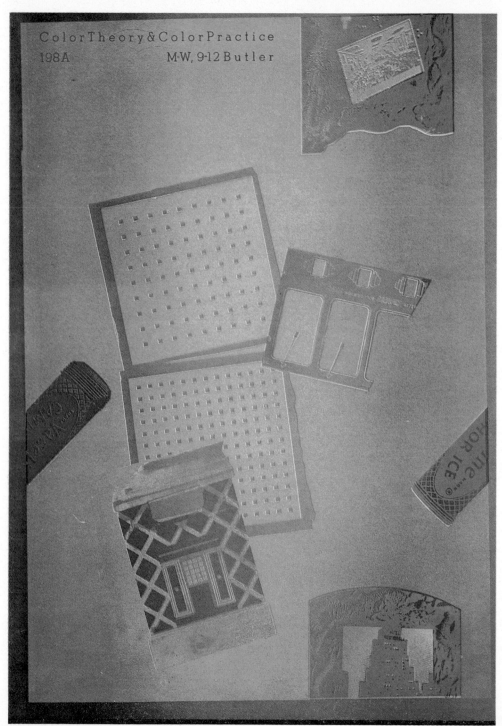

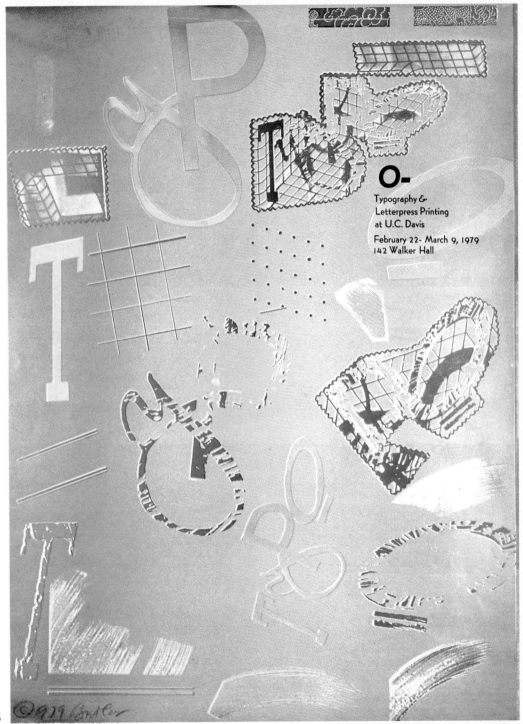

O-

Typography &
Letterpress Printing
at U.C. Davis

February 22- March 9, 1979
142 Walker Hall

©1979 Bricker

37. Poet reading fly-away paper
Colored Reading

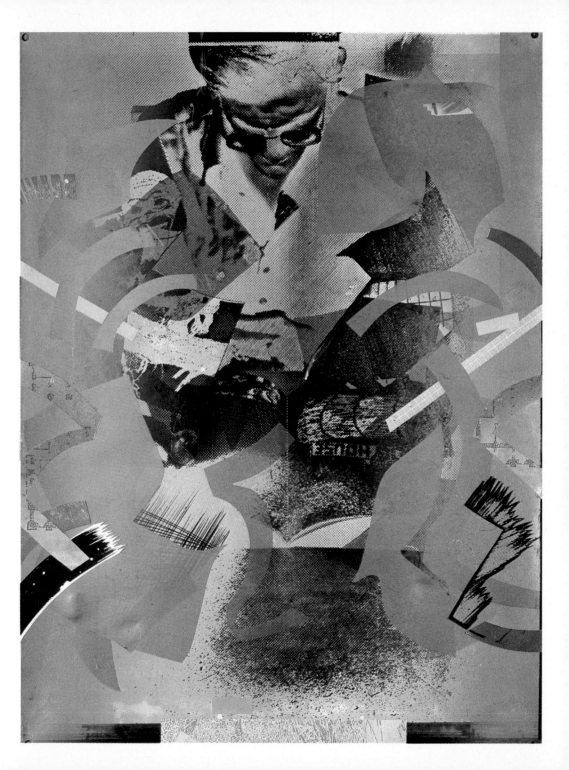

38. Swiss OK (after all)

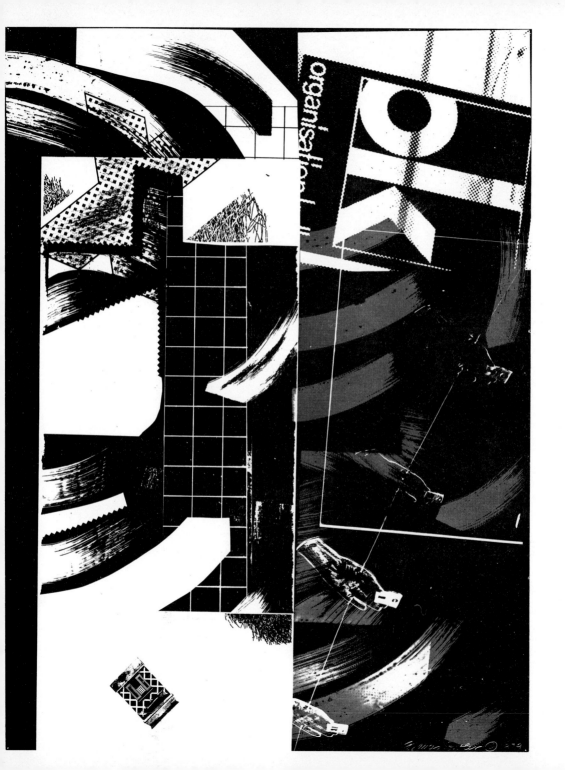

39. The burden of meaning, "I think it's a quote."

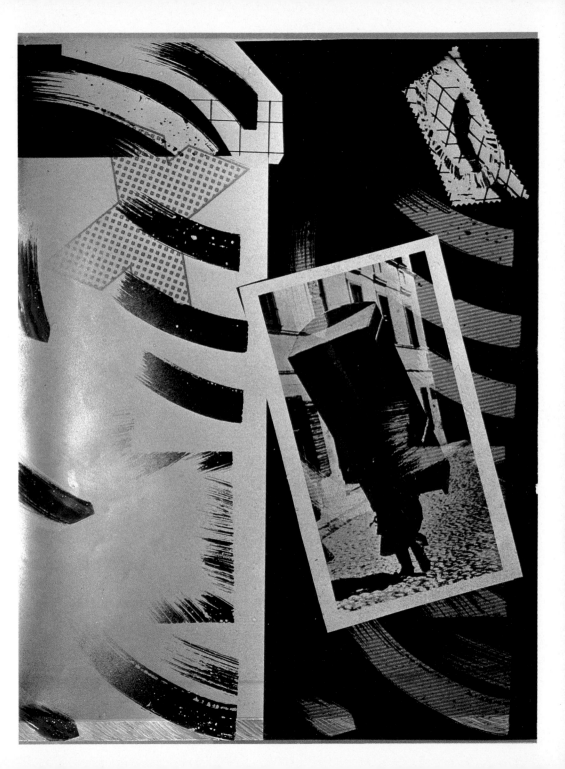

This book was set in Universe typefaces
by Mergenthaler Photocomposition at Holmes Typographers,
San Jose; and printed at Grafiche Editoriali Ambrosiane
S.p.A., Milan, Italy.